BURNE-JONES

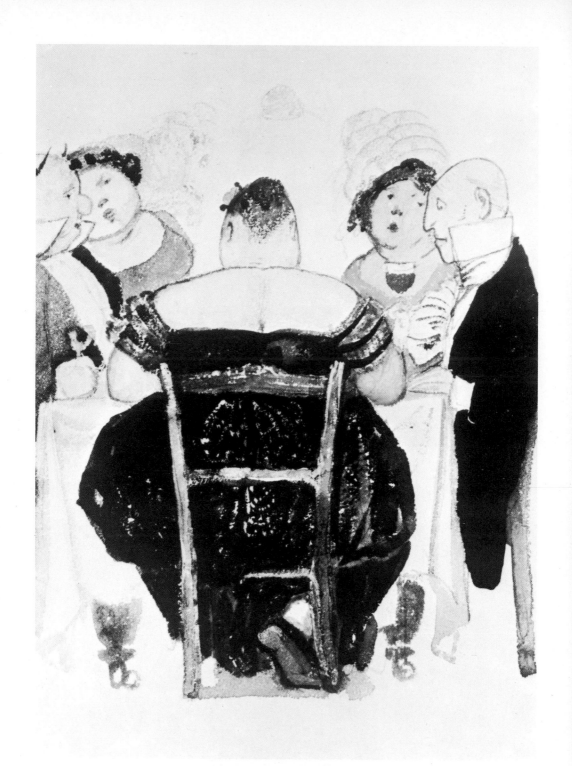

THE DINNER PARTY
c. 1890 Gouache 27 x 19 cm
Roy Miles Gallery, London

BURNE-JONES

ALL COLOUR PAPERBACK

Introduction by May Johnson

RIZZOLI
NEW YORK

First published in the United States of America in 1979 by
Rizzoli International Publications, Inc.
712 Fifth Avenue/New York 10019

Library of Congress Catalog Card Number 78-66217
ISBN 0- 8478-0210-8

Printed and bound in Hong Kong

Young Love lies dreaming
But who shall tell the dream?

Christina Rossetti *Dream-Love*

The ethereal land of day-dreams and reverie, of beauty, love and melancholy is revealed in the art of Edward Burne-Jones. Turning away from the reality of nineteenth-century technology he depicted instead the images of his imagination, and found in the legends and fables of the past and in the works of the Romantic poets matter more congenial to the painter's brush than the everyday world in which he was forced to live. In paintings, tapestries and stained glass Burne-Jones evoked a languid beauty and a dreamy nostalgia for a lost Golden Age of damozels and knights-errant, the heroes and heroines of romance.

Thus his work has been identified firstly with Pre-Raphaelitism and then with Aestheticism and Symbolism. The last two movements had in common a tendency to reject materialism and the portrayal of naturalistic scenes in favour of the imagery of the mind, and all shared a strong literary interest especially in poetry and myth. Burne-Jones made an important contribution in both style and subject-matter to all three but remained a distinct and idiosyncratic artistic character who evades categorisation and whose artistic roots lie in his own personal brand of aestheticism.

Burne-Jones was born in 1833. His mother died soon after the birth and his father, the owner of a gilding and framing business, at first rejected him. Apart from his timid and aloof parent, Burne-Jones was brought up by a Miss Sampson. It must have been a dull and rather lonely childhood and it seems that, as a boy, he retreated into the world of his imagination.

His boyish fantasies soon found expression in drawing, for which he had a natural talent. Fortunately the dreamy side of his nature was tempered by a puckish sense of humour which showed in the caricatures he executed for the amusement of his schoolfellows and which continued to delight his friends for the rest of his life — a quirky contrast to the solemn and static beauty of his major *oeuvre*.

After being educated at King Edward's School in Birmingham and learning the principles of drawing in evening classes at the Government School of Design, Burne-Jones went up to Exeter College, Oxford in 1852 with the intention of entering the Church. Here he met William Morris, also destined for the Church, and so began a friendship that was to last a lifetime. Both shared the same tastes; a fascination for the Middle Ages, literature and fantasy and a dislike of modern industrial society. At Oxford Burne-Jones was surrounded by picturesque Medieval architecture and read Chaucer, Keats, Coleridge, Ruskin and Tennyson. His religious vocation began to waver. Finally, after a visit to Northern France with Morris, he decided to devote his life to art instead. Soon after he discovered Thomas Malory's *Morte d'Arthur* — a tale which embodied all the elements of legend and mysticism after which he hankered.

Burne-Jones started his artistic career under the guidance of Dante Gabriel Rossetti whose work he had first seen and admired in 1855. Rossetti, also a poet, infused his paintings with an intensity which Burne-Jones had hitherto only found in literature. Burne-Jones had also become acquainted with the pictures of Millais and Holman Hunt but it was under Rossetti's aegis that he was to join, as a young recruit, the Pre-Raphaelite movement. He and Morris (who had also abandoned the church for art) set up a studio at 17, Red Lion Square in London where they lived in an atmosphere of jovial Bohemianism. During this time Burne-Jones produced small drawings, some designs for stained glass and a mural for the Oxford Union project. It was only in the 1860s, however, after his marriage to Georgiana Macdonald, that he started to execute larger and more ambitious pictures.

Morris, meanwhile, after studying architecture, was to turn to the design and production of applied arts and founded Morris and Co. in 1861. He remained, as a designer and pioneer of the Arts and Crafts movement and in his ideas and ideals, a decisive influence on Burne-Jones whose work in the applied arts bears the hallmark of the meticulous craftsmanship and attention to detail that Morris encouraged and fostered. Morris's *The Earthly Paradise*, a quasi-medieval collection of writings, also provided Burne-Jones with various themes for his pictures.

Burne-Jones's early works, however, show his debt to Rossetti. The colours are rich and vibrant with outlines blurred and soft, and slim, wraith-like figures. *The Annunciation, The Flower of God* (1863) recalls late Medieval illuminated manuscripts and Flemish religious painting while *Fair Rosamund and Queen Eleanor* (1862) illustrates the ballad of the fated mistress of Henry II. The portraits of the sorceress *Sidonia von Borke* (1860) and her cousin's virtuous wife Clara were also based on a literary source — Wilhelm Meinhold's *Sidonia the Sorceress*, published in an English translation in 1849 — and mingle the compelling themes of sweetness and virtue versus evil beauty and witchcraft.

Gradually Burne-Jones's style became more clearly defined. He visited Italy several times, first in 1859 and then with Ruskin in 1862 and twice more in 1871 and 1873. The early Renaissance masters with their clarity of form, crisp delineation, monumental figures and light, cool colours were to have a profound influence upon him. Most important amongst these painters was the fifteenth-century Florentine artist Botticelli whose works, with their delicate, grave beauty, sinuous rhythmic line and mysterious symbolism provided a stylistic tradition of which Burne-Jones could feel himself an inheritor. In Rome, Michelangelo provided him with a model for his conception of the ideal beauty of the nude, although, unlike Michelangelo, Burne-Jones's nudes veered towards a feminine rather than a masculine ideal.

Cupid Delivering Psyche (1867) is a transitional work. The stronger, fuller forms and swirling drapery look Italianate but the outlines are still soft and undefined. *The Four Seasons* (1869) are similarly classical in tone, rather in the manner of Albert Moore. This series was painted for the Liverpool shipowner Frederick Leyland for his 'aesthetic' interior at 49, Prince's Gate, London. The features of Maria Zambaco, Burne-Jones's mistress, appear in the guise of flower-strewn *Summer*. William Morris wrote the verses beneath the figures.

In 1877, at the Grosvenor Gallery, the full impact of Burne-Jones's mature style became apparent. The seven pictures he exhibited there included *The Beguiling of Merlin* (1872-77), portraying King Arthur's magician entwined amongst a writhing, twisting hawthorn, lulled there by the enchantress Nimuë. The whole painting depends on the interplay of twisting, undulating curves, the canvas decorated with swirling masses of drapery and foliage. The following year he exhibited *Laus Veneris* (1873-75), based on the legend of Tannhäuser, depicting a scene of claustrophobic langour with the rich detail and brilliant colour of a fifteenth-century tapestry.

From then until his death Burne-Jones's style changed little, becoming only more refined and polished with the emphasis on ornament and decoration and the movement of line rather than the textural qualities of paint. Colours oscillated from hues of medieval lustre and brilliance to cold, icy monochromes or subdued richness as in *King Cophetua and the Beggar Maid* (1884).

This picture is probably his most famous work. The subject was based on a poem by Tennyson:

> So sweet a face, such angel grace,
> In all that land had never been:
> Cophetua swore a royal oath:
> 'This beggar maid shall be my queen'.

The king sits, his crown in his hands, gazing up in humility at a vision of such pure beauty that it transcends all material cares, power and wealth. Although the figures, set against a richly ornamental background, are static and restrained, the picture emits an air of tension that is strangely removed from the spectator, an elaborate, jewel-like icon on the worship of beauty.

Increasingly Burne-Jones's pictures emanated a sense of mystery and hidden symbolism. The subject-matter, so often based on poetry or legend, seemed to indicate allegorical sources, the pursuit of eternal truths and the cult of beauty. This aura of mysticism is heightened by the idealisation of his figures, their expressions rendered ambiguous by the use of chiaroscuro. Often every inch of the canvas is filled with detail, denying a sense of space and thereby creating the illusion of an enclosed and unearthly world.

His pictures were the subject of endless discussion and controversy among his contemporaries. Henry James wrote of *The Mill* in 1882: '... I have not the least idea who the young women are, nor what period of history, what time and place, the painter has in his

mind. His dancing maidens are exceedingly graceful, innocent, maidenly: they belong to the land of fancy and to the hour of reverie!'

It is easy to see why Burne-Jones came to be associated with Aestheticism and its 'art for art's sake' and with Symbolism and its esoteric themes and visual enigmas. Burne-Jones's visions, however, are more personal, and perhaps his pictures have been overlaid with a significance not really intended by the artist. Despite their mysterious qualities, they retain a certain nineteenth-century flavour; an air of innocence and a preference for sweetness and languor and the romantic aspects of literature which contain none of the decadence, blatant eroticism or even ugliness which was a feature of the work of various Symbolist and Aesthetic artists (notably Beardsley).

Burne-Jones became, during the 1880s and 1890s, an established and successful artist. The University of Oxford awarded him an Honorary Degree in 1881; he was created a *chevalier* of The Legion of Honour in 1889 and, the final seal of approval, created a baronet by Queen Victoria in 1894 (although his public popularity was, by this time, waning). These years saw the production of large and highly wrought pictures including the series of the *Perseus* cycle and the final *Briar Rose* scheme.

The *Perseus* cycle was commissioned by Arthur Balfour for his music room at 4, Carlton Gardens, London and, apart from its obvious classical debt, was based on *The Doom of King Acrisius* from Morris's *The Earthly Paradise. Perseus and the Graiae* (1892), a stark, cold, and greenish-grey painting illustrates Perseus snatching the single eye which the three Graiae share between them. Witholding their most precious possession, they are thus forced to give him the information he needs to seek out Medusa. Typically, Burne-Jones has represented the Graiae as graceful maidens rather than the ugly hags of classical myth. *The Baleful Head* (1886-87) is another picture from the same series illustrating Perseus showing Andromeda the head of Medusa reflected in a well. They stand within a walled garden which may be intended as a type of celestial arbour containing a symbolic apple-tree. Certainly the legend of Perseus contained themes which appealed strongly to Burne-Jones's nature — the conquest of evil and the triumph of beauty, virtue and valour.

The *Briar Rose* series, which was bought by the first Lord Faringdon in 1890, illustrates Perrault's fairy tale of the Sleeping Beauty, in which Burne-Jones has captured brilliantly the atmosphere of the silent, somnolent court reclining amidst a thorny thicket of roses, the sumptuous detail enhanced by the gentle, graceful rhythm of the sleeping people. Through most of Burne-Jones's pictures of the 1880s and 1890s, such as the Michelanglesque *The Wheel of Fortune* (1872-86) and *The Tree of Forgiveness* (1884), runs this rhythmic line which becomes the dominating force of the composition in *Sponsa di Libano* (1891) where the folds of material become an excuse for stylised flounces and furbelows.

Burne-Jones's inclination towards pattern-making was particularly suited to the applied arts as in the tapestries of *The Heart of the Rose* (1901) and *Love Leading the Pilgrim* (1909). His many designs for stained glass reach their apogee in the superbly stylised linear curves of *The Pelican* (c. 1880), symbol of the Passion of Christ. In 1882 he also began a set of water-colour designs for a flower book based on the visual images inspired by flowers. These water-colours are delicately and softly painted, a contrast to his larger works.

Burne-Jones died on 16th June 1898. His legacy to the art world was prolific — paintings, illustrations, stained glass and tapestries, all of which reflected an essentially feminine beauty and grace, a vision of Venus as the epitome of a noble ideal — an ideal which could be sad, reflective or bitter-sweet but in which ugliness, old age, misery and degradation had no place. At its worst his work lacked vigour and dynamism but at its best, he produced some of the most evocative images of reverie and fairy-tale.

Aside from his short-lived contribution to Pre-Raphaelitism and the association, albeit tentative, with Aestheticism and Symbolism, perhaps Burne-Jones's greatest influence lies in the field of decorative design, — the use of sinuous, flowing line, the opposition of static forms against frothy, blossoming flowers or tangled webs of branches and leaves, bejewelled and encrusted caskets, crowns and armour set against diaphanous, clinging drapery or robes gathered into a multitude of heavy, hanging folds. In this, the decoration transcends the subject and story, creating abstract patterns pervaded by an insidious undulating rhythmic line, the same organic rhythm that was to emerge in Art Nouveau. It was a style admirably suited to a spiritual ideal, the late nineteenth-century arcadia of Burne-Jones's imagination.

1

SIDONIA VON BORKE 1560
1860 Gouache 33 x 17 cm
The Tate Gallery, London

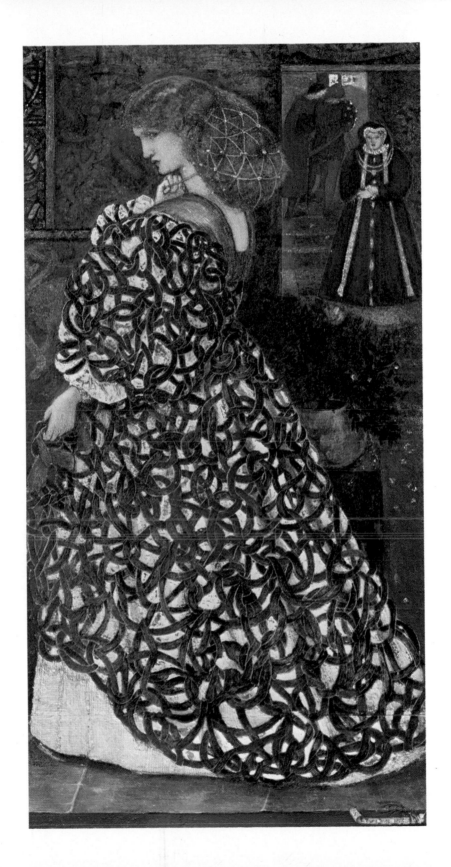

2

CLARA VON BORKE 1560
1860 Gouache 34 x 18 cm
The Tate Gallery, London

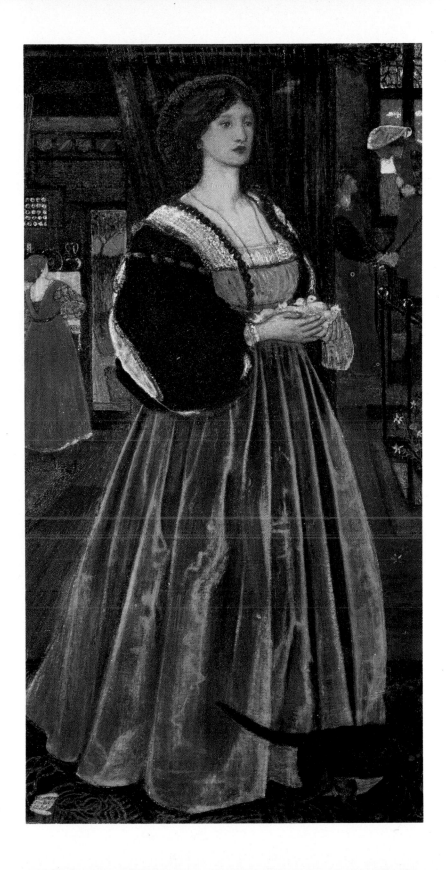

3

INTERIOR WITH FIGURES
c. 1860 Mixed media, paper laid on board
21.5 x 34 cm
Private collection, London

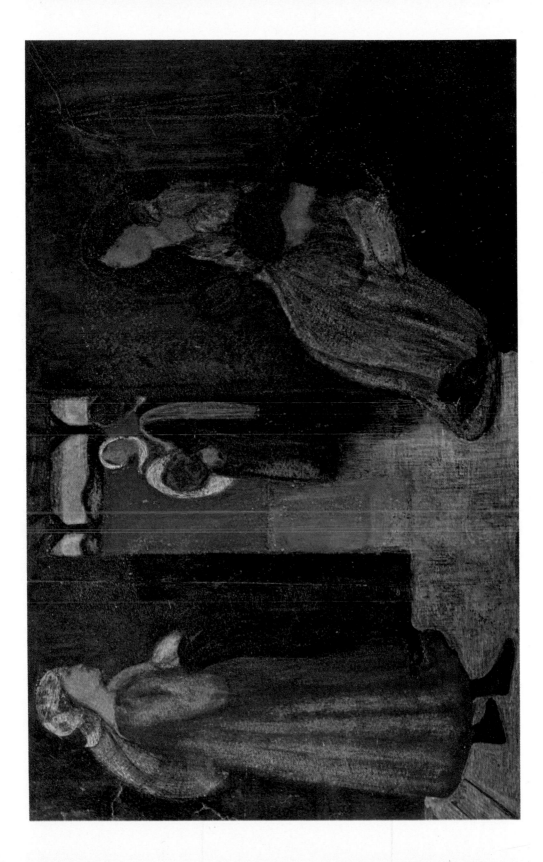

4

KING RENE'S HONEYMOON
Alternative design for the King René
cabinet made by Morris & Co.
1861 Gouache 49.5 x 36 cm
The Fine Art Society, London

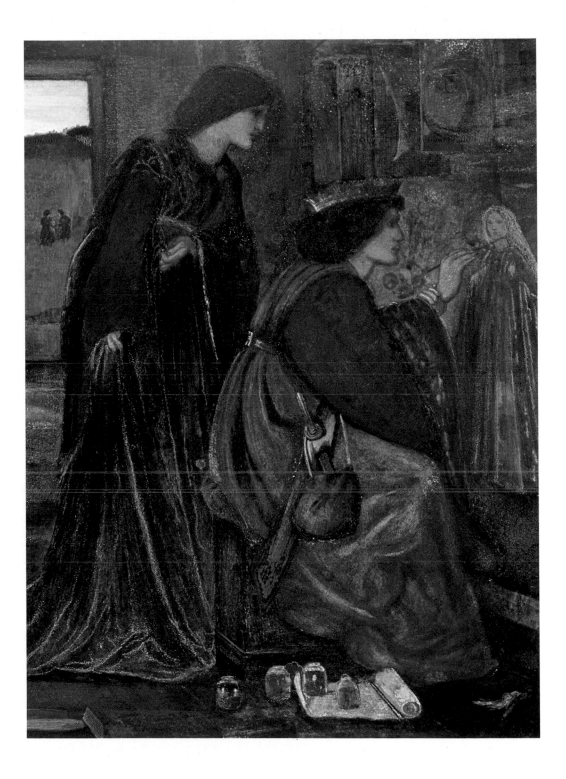

5

FAIR ROSAMUND AND QUEEN ELEANOR
1862 Gouache 26 x 27cm
The Tate Gallery, London

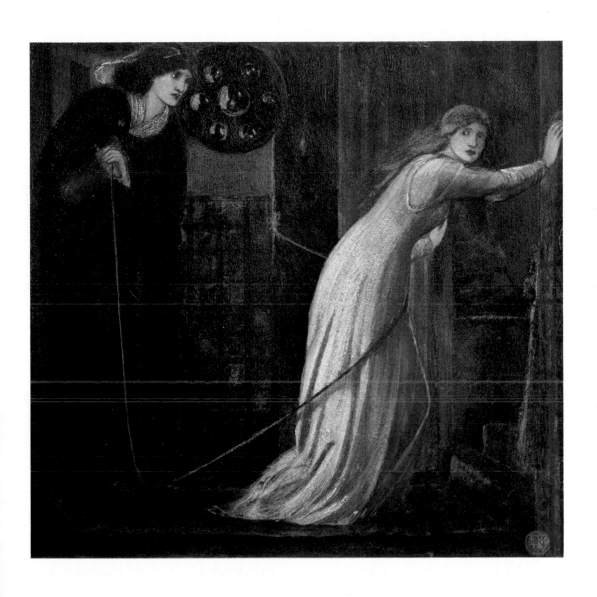

6

THE MADNESS OF SIR TRISTRAM
1862 Gouache 59 x 56.5 cm
Leger Galleries, London

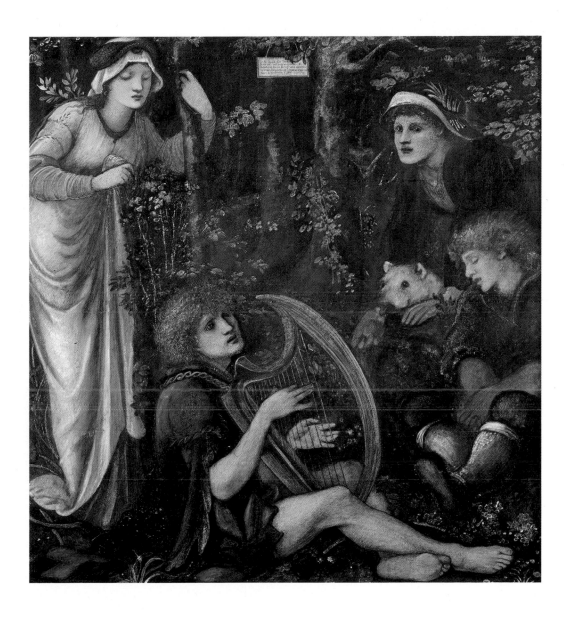

7

MORGAN LE FAY
1862 Gouache 86.5 x 48 cm
London Borough of Hammersmith
Public Libraries

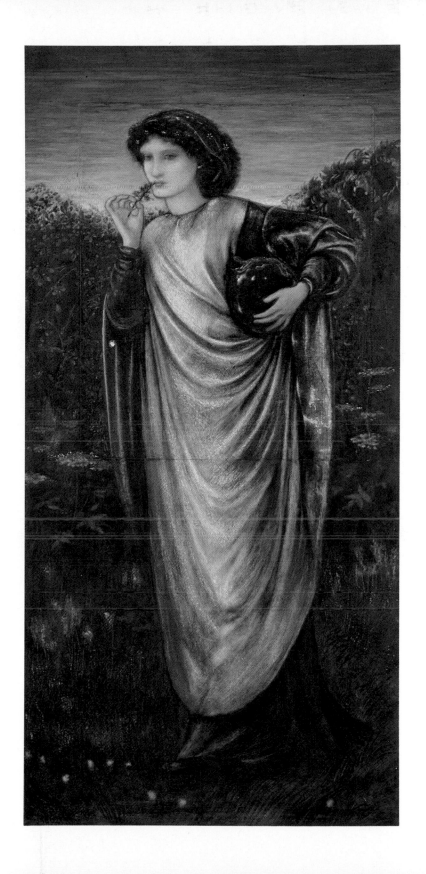

8

THE ANNUNCIATION, THE FLOWER
OF GOD
1863 Gouache 60.5 x 52.5 cm
Roy Miles Gallery, London

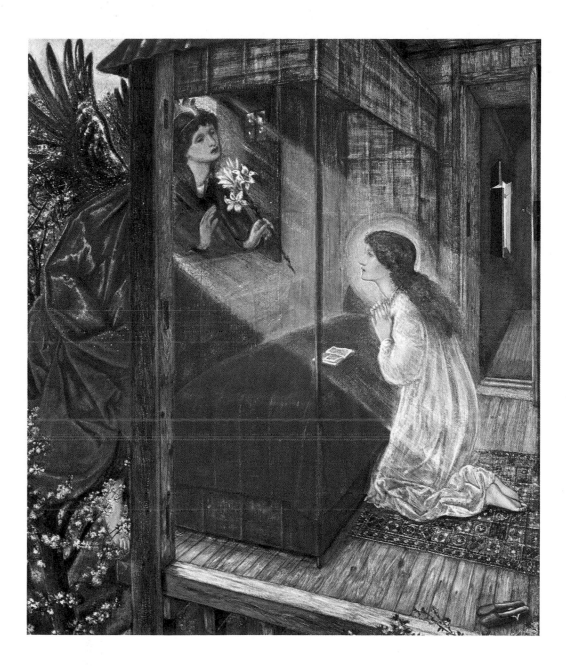

9

ZEPHYRUS AND PSYCHE
1865 Gouache 43 x 26 cm
The Fine Art Society, London

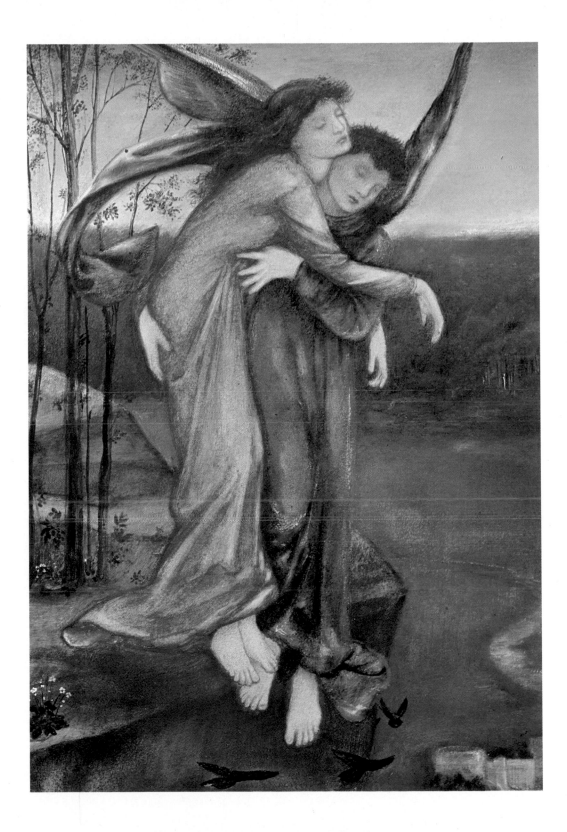

10

THE GARLAND
1866 Gouache 76 x 45.5 cm
London Borough of Hammersmith
Public Libraries

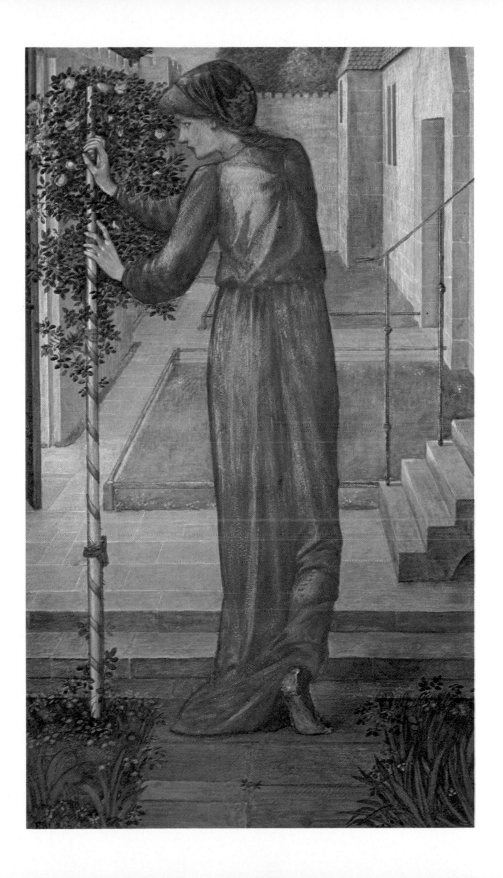

11

CUPID DELIVERING PSYCHE
1867 Gouache 80 x 91.5 cm
*London Borough of Hammersmith
Public Libraries*

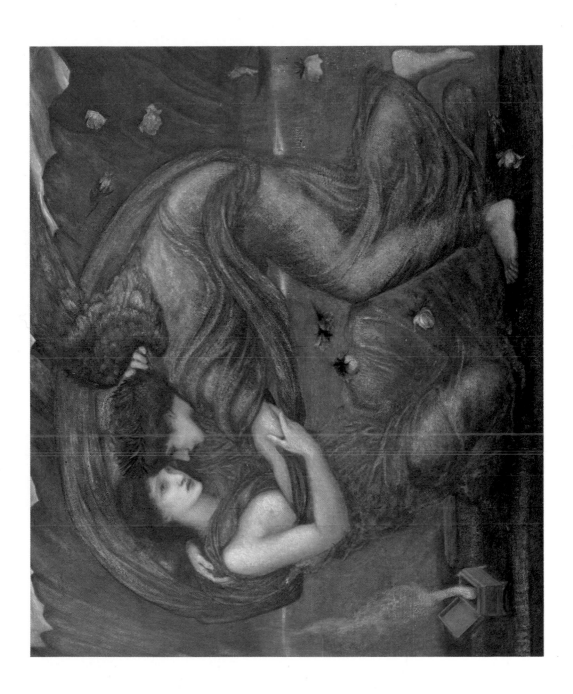

12

THE FOUR SEASONS: SPRING
1869 Gouache 122.5 x 45 cm
MacMillan and Perrin Gallery, Vancouver

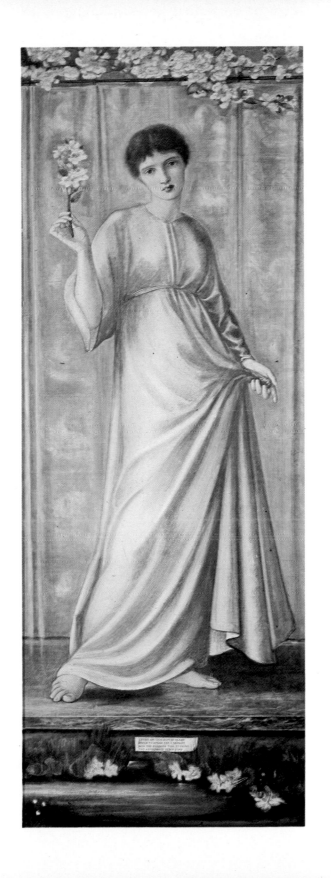

13

THE FOUR SEASONS: SUMMER
1869 Gouache 122.5 x 45 cm
MacMillan and Perrin Gallery, Vancouver

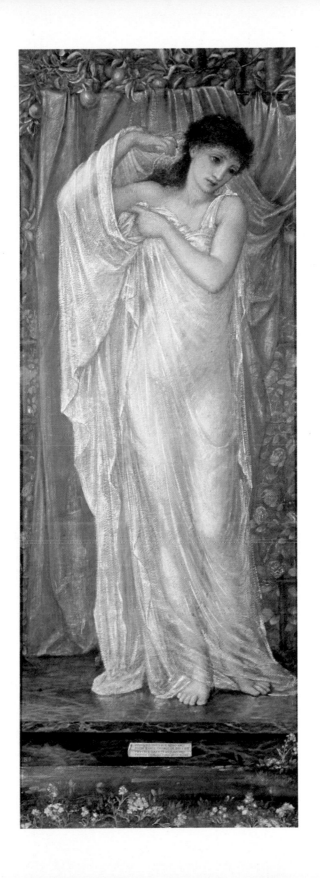

14

THE FOUR SEASONS: AUTUMN
1869 Gouache 122.5 x 45 cm
MacMillan and Perrin Gallery, Vancouver

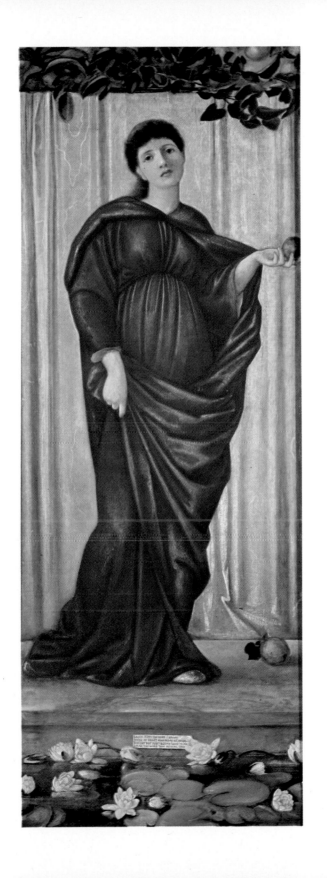

15

THE FOUR SEASONS: WINTER
1869 Gouache 122.5 x 45 cm
MacMillan and Perrin Gallery, Vancouver

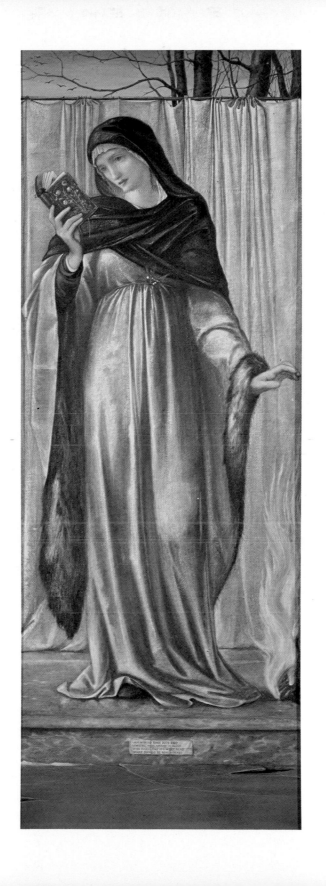

16

MUSIC
c. 1865-70? Gouache 67.5 x 43 cm
Sotheby's Belgravia, London

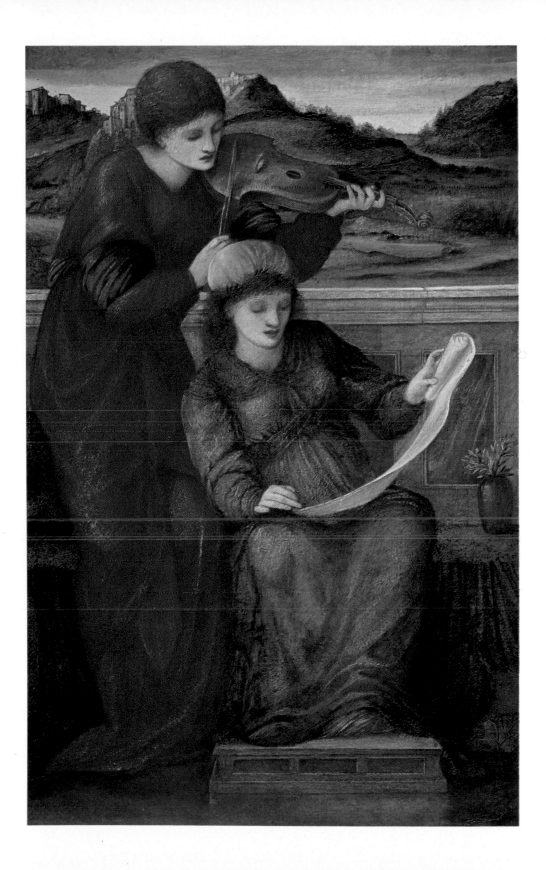

17

THE KING'S WEDDING
1870 Gouache with gold paint on vellum
32 x 26 cm
Roy Miles Gallery, London

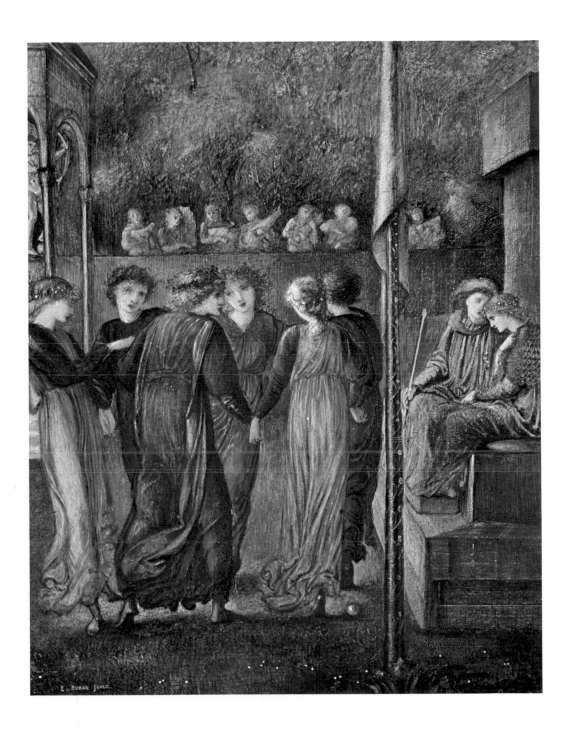

18

THE SLEEPING KNIGHTS
From the Briar Rose series
c. 1870 Oil 61 x 82.5 cm
The Walker Art Gallery, Liverpool

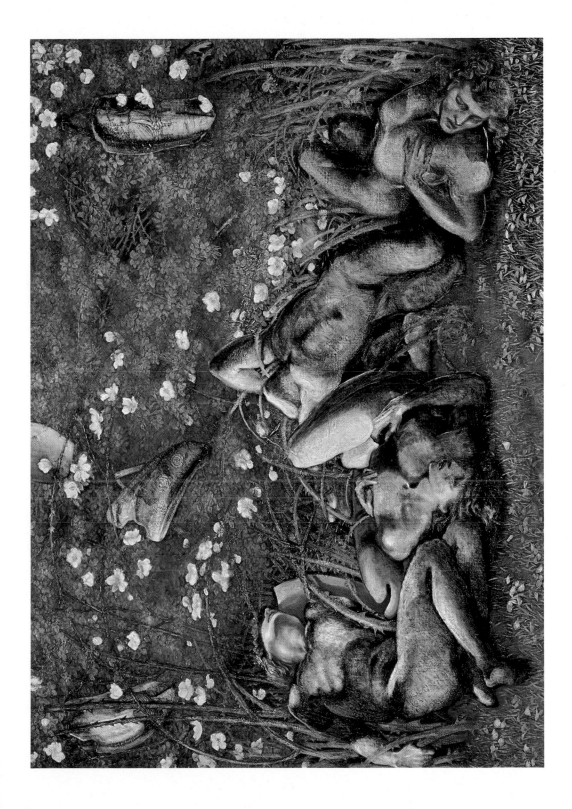

19

THE PASSING OF VENUS
c. 1875 Oil 57 x 115.5 cm
Sotheby's Belgravia, London

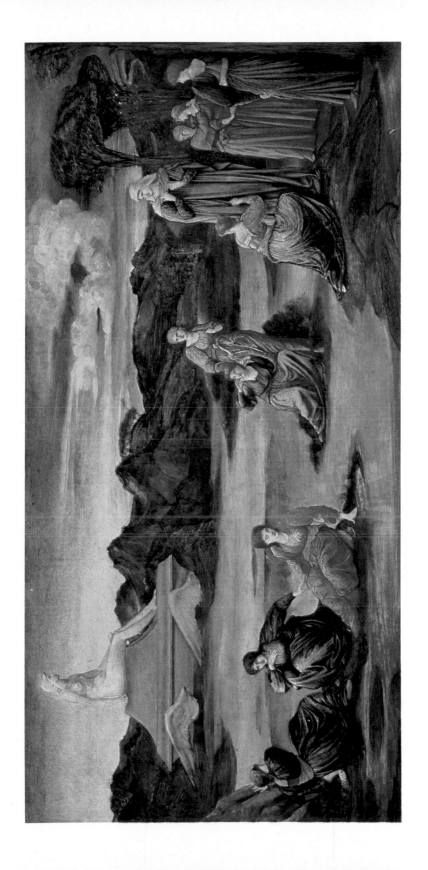

20

**PERSEUS RECEIVING THE MIRROR
FROM ATHENA**
1877 Gouache 152.5 x 127 cm
Southampton Art Gallery & Museums

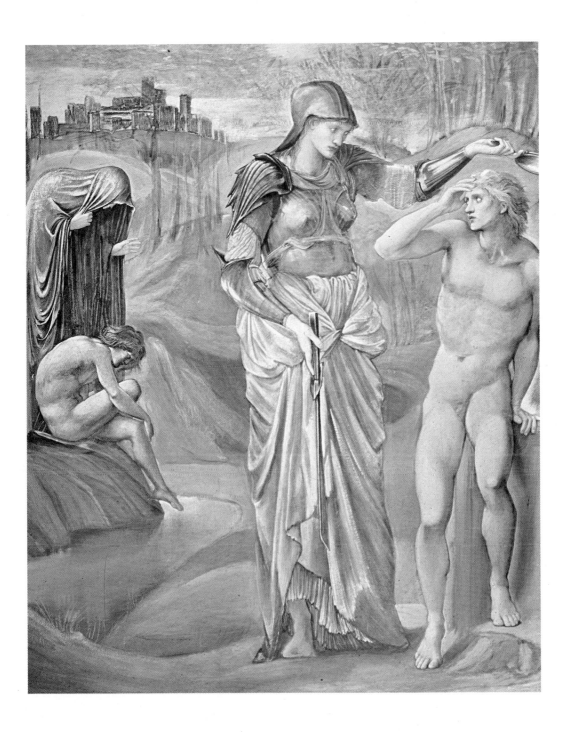

21

THE BEGUILING OF MERLIN
1872-77 Oil 186 x 111 cm
Lady Lever Art Gallery, Port Sunlight

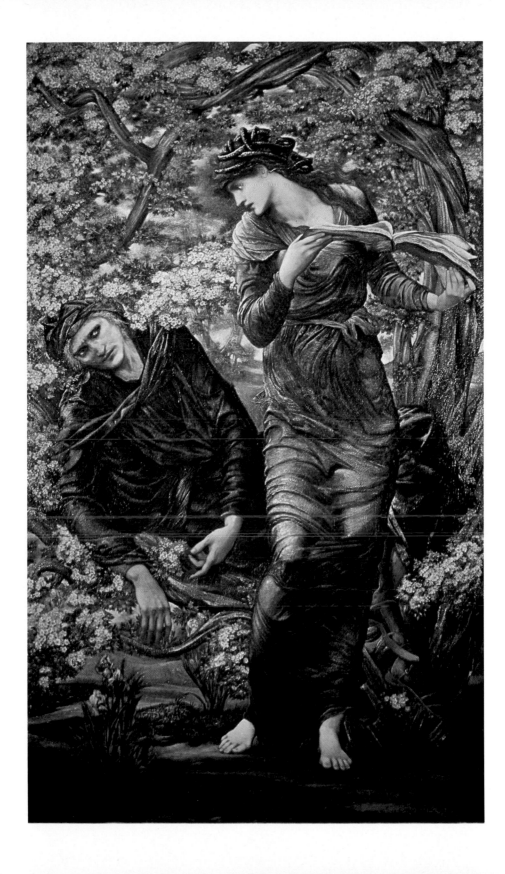

22

THE MIRROR OF VENUS
1873-77 Oil 122 x 199.5 cm
Calouste Gulbenkian Foundation, Lisbon

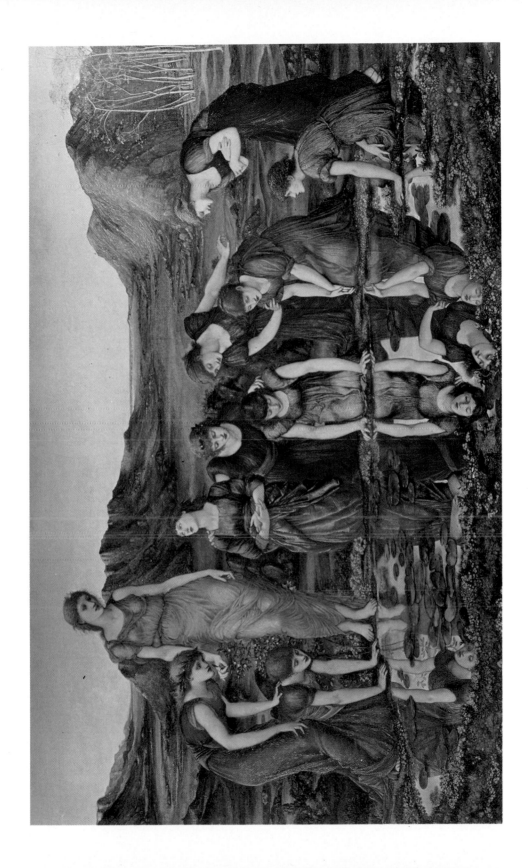

23

LAUS VENERIS
1873-75 Completed 1878 Oil 122 x 183 cm
Tyne and Wear County Museums Service,
Laing Art Gallery, Newcastle-on-Tyne

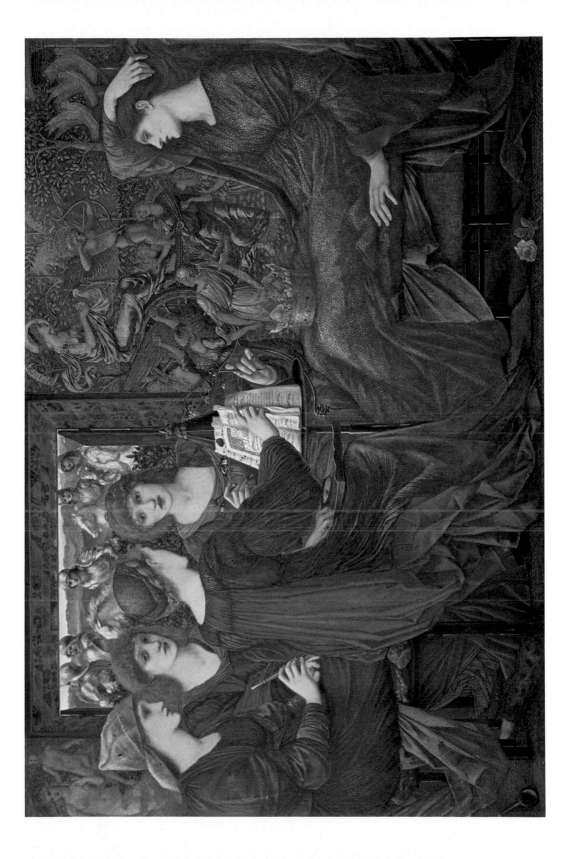

24

THE AVENGING ANGEL OF ST. CATHERINE

1878 Gouache 43 x 23.5 cm
*London Borough of Hammersmith
Public Libraries*

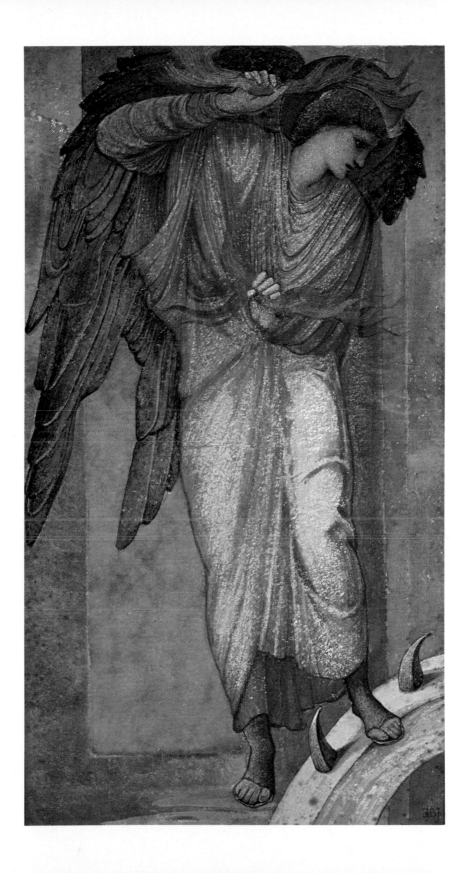

25

PORTRAIT OF FRANCES GRAHAM
(later Mrs. Horner)
1879 Gouache 58.5 x 43 cm
Sotheby's Belgravia, London

26

THE MILL (detail)
1882 Oil 91 x 197.5 cm (whole panel)
Victoria & Albert Museum, London

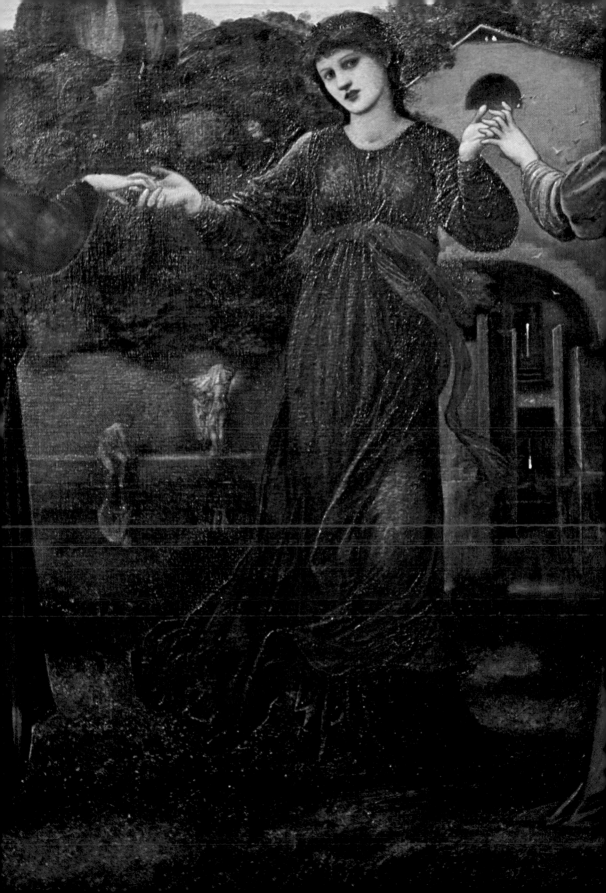

27

THE TREE OF FORGIVENESS
1884 Oil 191 x 106 cm
Lady Lever Art Gallery, Port Sunlight

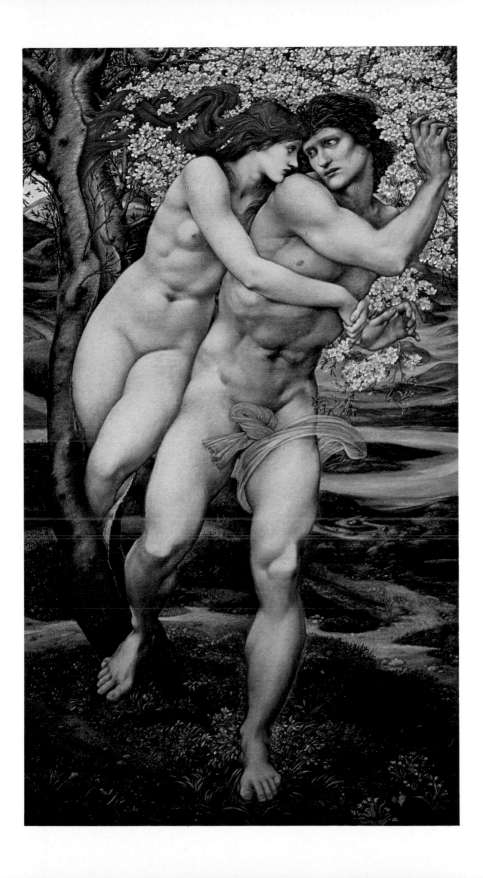

28

**KING COPHETUA AND THE
BEGGAR MAID**
1884 Oil 290 x 136 cm
The Tate Gallery, London

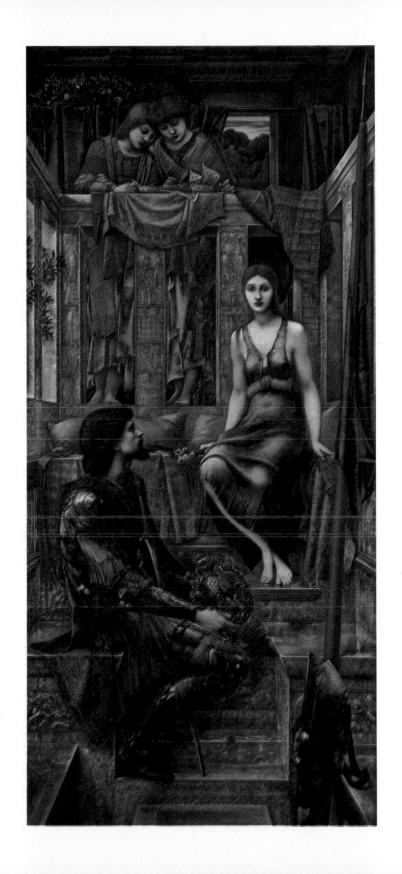

29

THE WHEEL OF FORTUNE
1872-86 Gouache 114.5 x 53.5 cm
London Borough of Hammersmith
Public Libraries

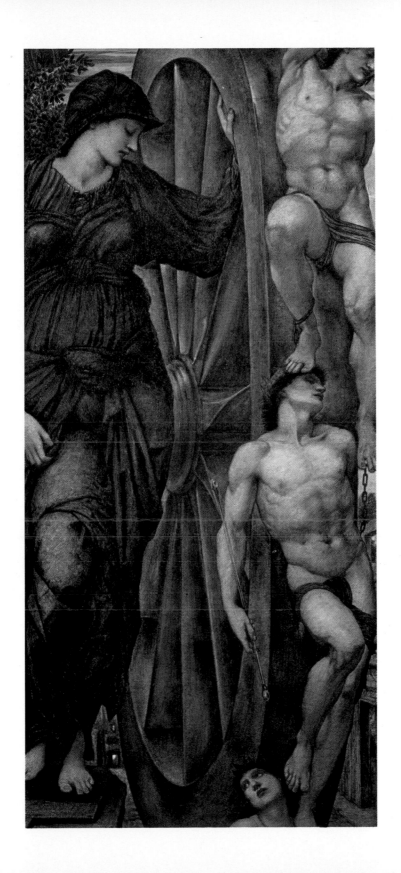

30

THE BALEFUL HEAD
From the Perseus cycle
1886-87 Oil 155 x 130 cm
Staatsgalerie Stuttgart

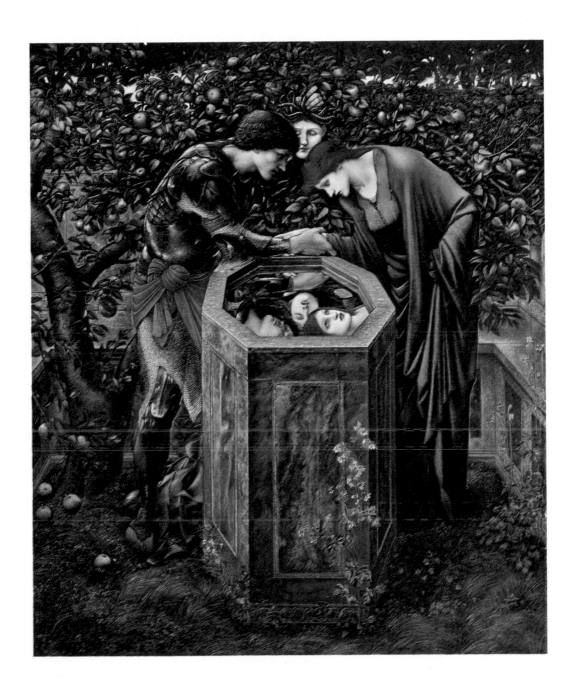

31

THE STAR OF BETHLEHEM (study)
1887 Gouache 33 x 15.5 cm
*London Borough of Hammersmith
Public Libraries*

32

THE GARDEN COURT (detail)
From the Briar Rose series
1873-90 Oil 125 x 231 cm (whole panel)
Faringdon Collection Trust, Buscot Park

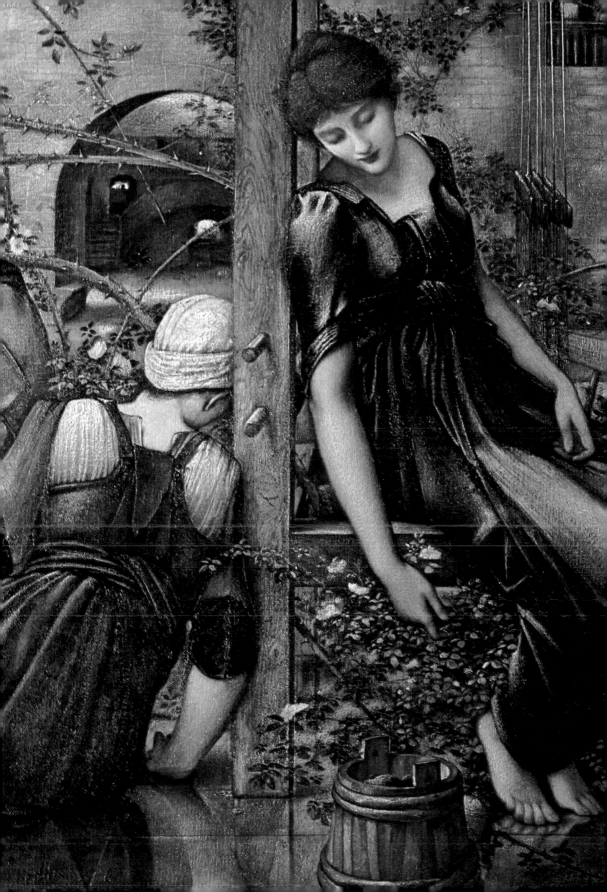

33

SPONSA DI LIBANO
1891 Watercolour 324 x 156 cm
The Walker Art Gallery, Liverpool

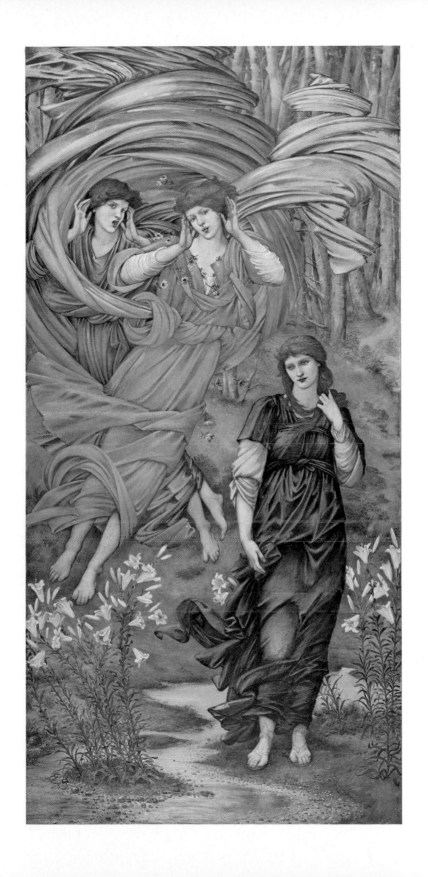

34

PERSEUS AND THE GRAIAE
1892 Oil 153.5 x 170 cm
Staatsgalerie Stuttgart

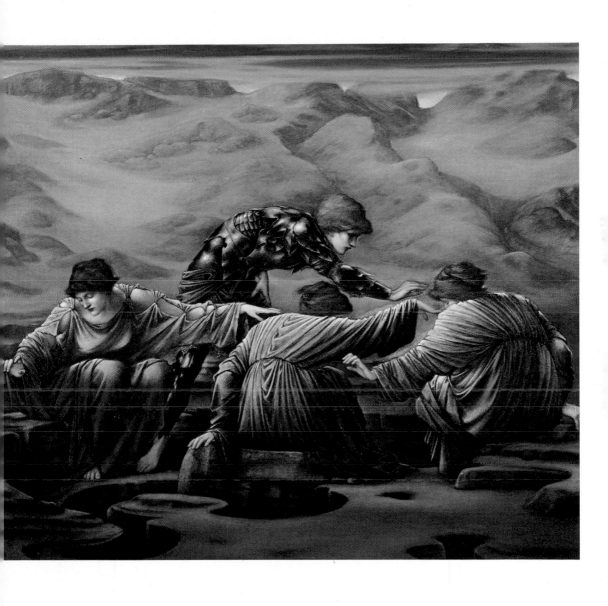

35

LOVE AMONG THE RUINS
1893 Oil 95.5 x 161.5cm
National Trust, Wightwick Manor

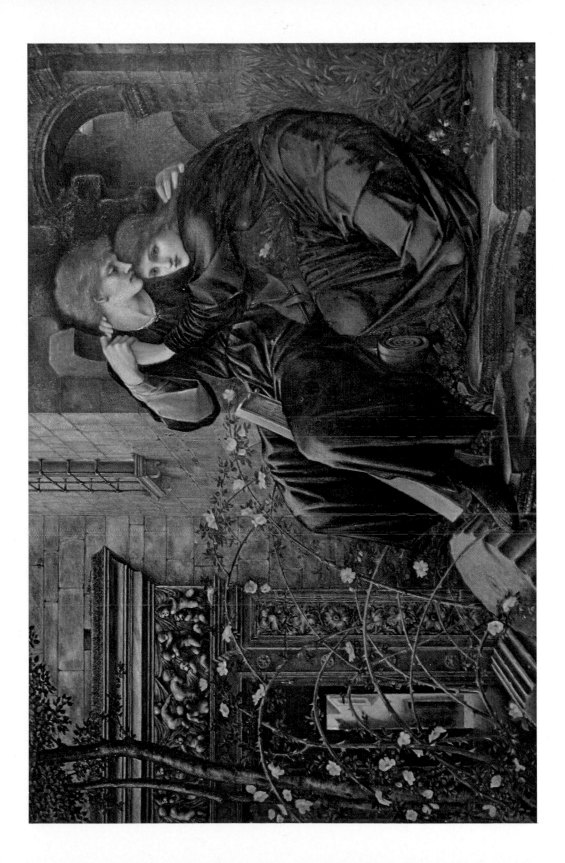

36

THE CHALLENGE IN THE WILDERNESS
c. 1894-98 Oil 127 x 97.5 cm
Christie's, London

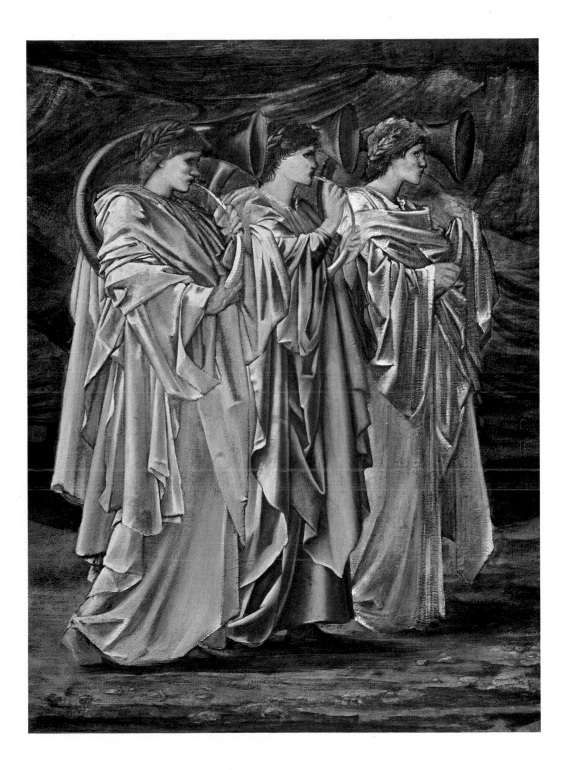

37

THE PELICAN
c. 1880 Cartoon for stained glass, later
coloured with chalks 172 x 57 cm
*William Morris Gallery, Walthamstowe. Photo
Clive Friend, FIIP (Woodmansterne Ltd.)*

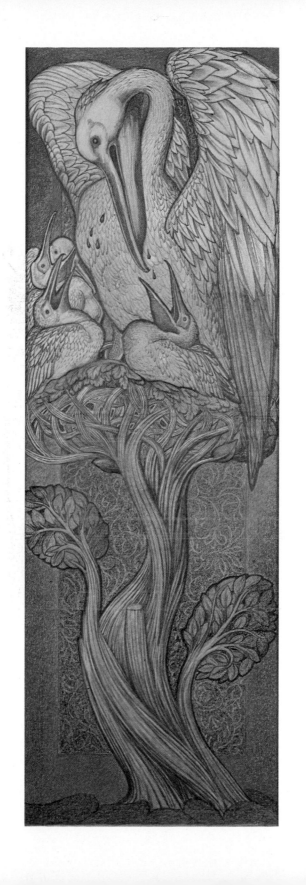

38

SANTA MARIA VIRGO (left)
c. 1880 Cartoon for stained glass, later
coloured with chalks 171.5 x 56 cm
Sotheby's Belgravia, London

SANTA DOROTHEA (right)
c. 1880 Cartoon for stained glass, later
coloured with chalks 171.5 x 56 cm
Sotheby's Belgravia, London

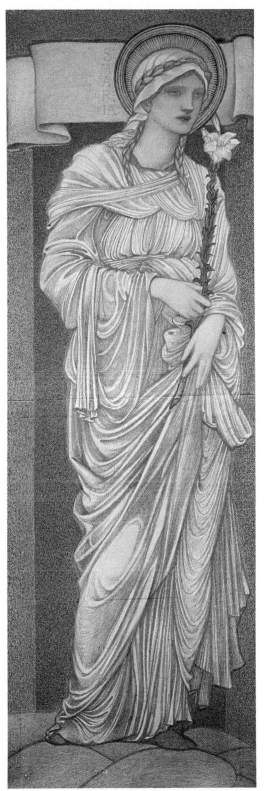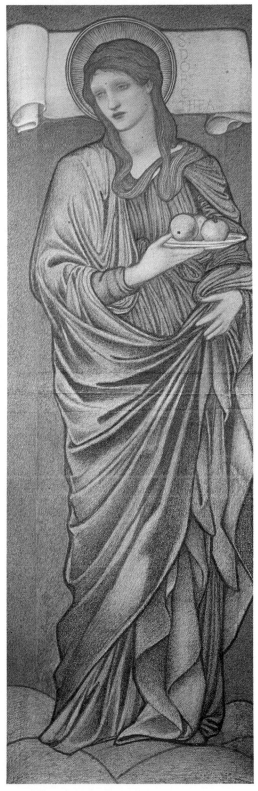

39

LADDER OF HEAVEN
1882-98 Watercolour 16.5 cm diam
The British Museum, London

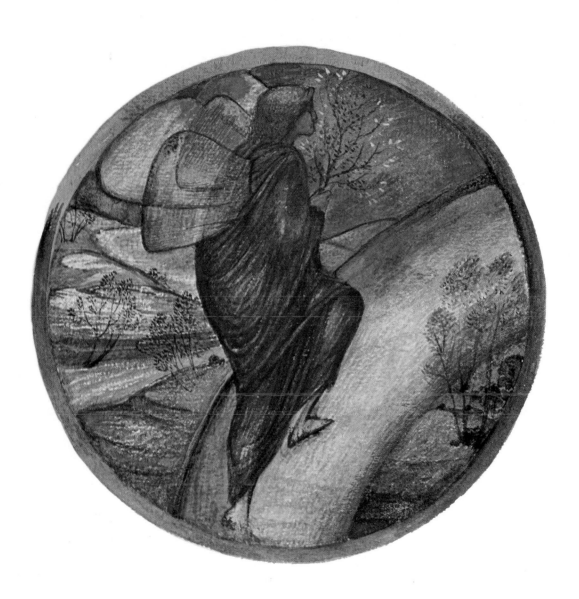

40

WAKE DEAREST
1882-98 Watercolour 16.5 cm diam
The British Museum, London

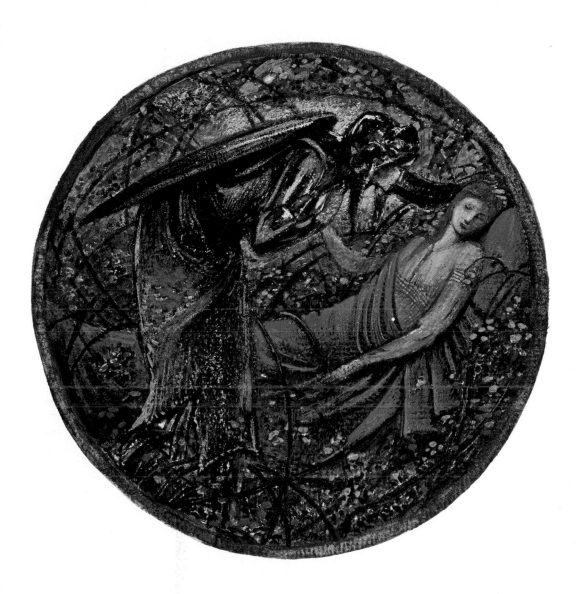

41

GOLDEN SHOWER
1882-98 Watercolour 16.5 cm diam
The British Museum, London

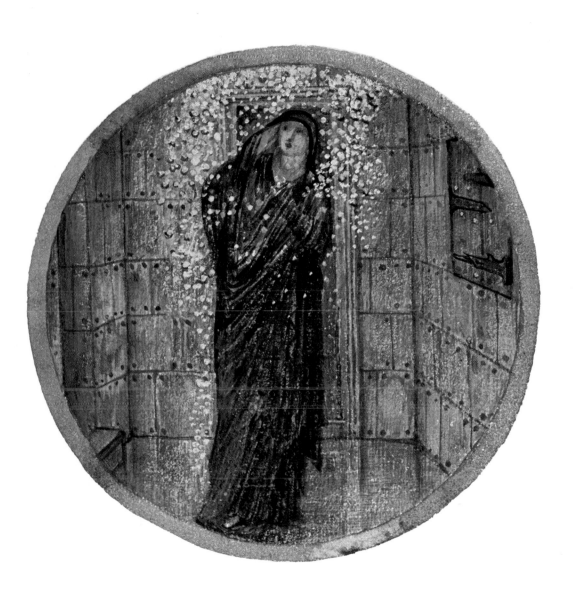

42

ADDER'S TONGUE
1882-98 Watercolour 16.5 cm diam
The British Museum, London

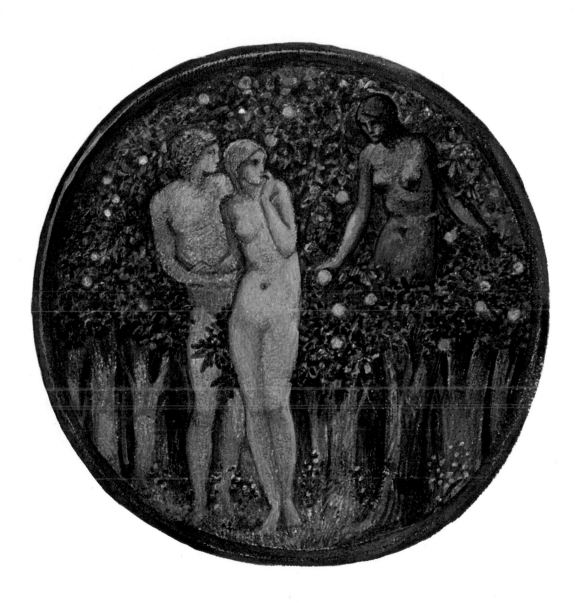

43

WHITE GARDEN
1882-98 Watercolour 16.5 cm diam
The British Museum, London

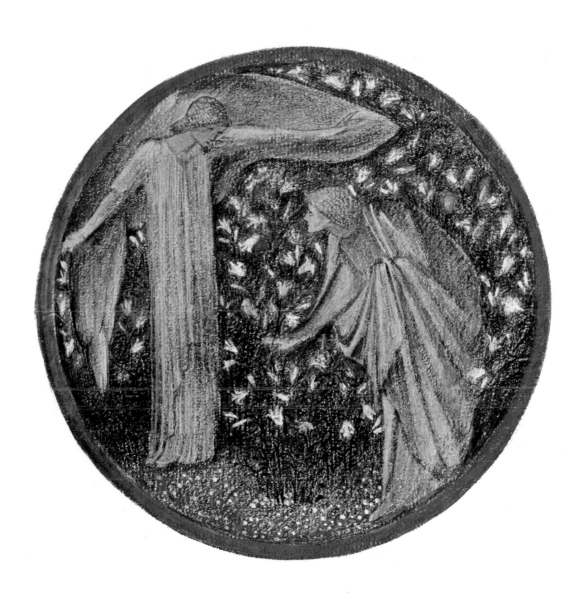

44

TRAVELLER'S JOY
1882-98 Watercolour 16.5 cm diam
The British Museum, London

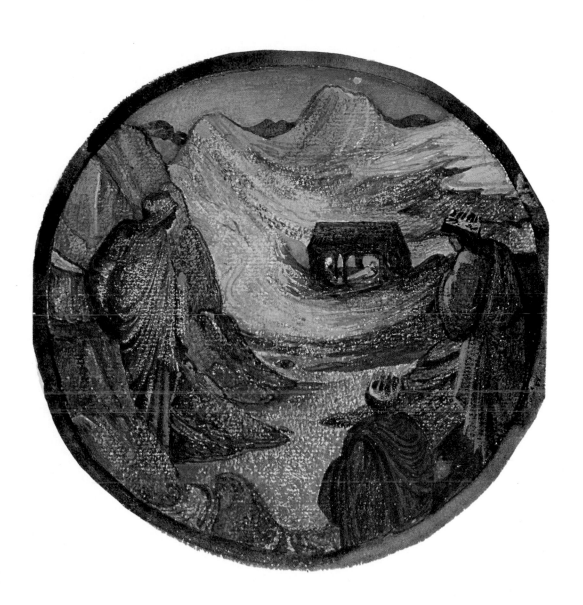

45

WITCH'S TREE
1882-98 Watercolour 16.5 cm diam
The British Museum, London

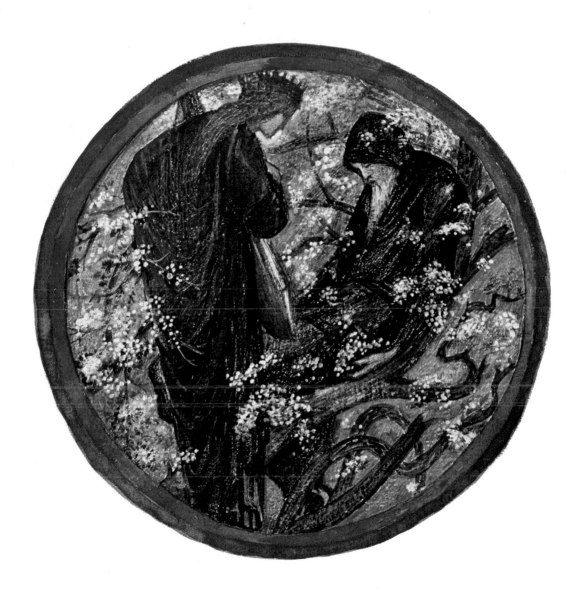

46

FIRE TREE
1882-98 Watercolour 16.5 cm diam
The British Museum, London

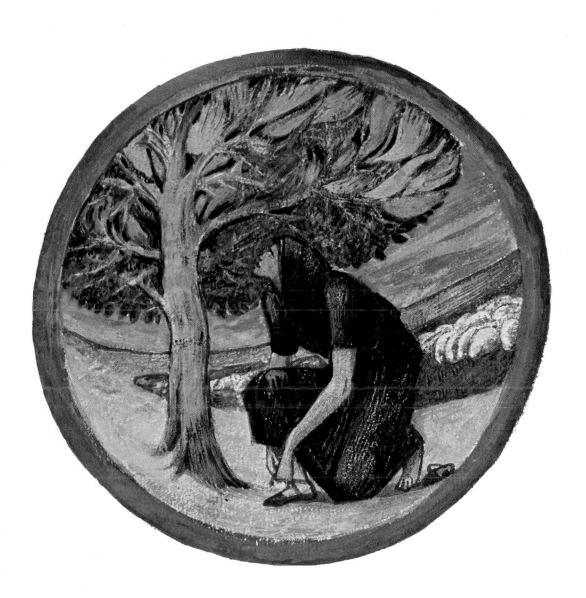

47

THE HEART OF THE ROSE
1901 Wool tapestry 155 x 201 cm
Sotheby's Belgravia, London

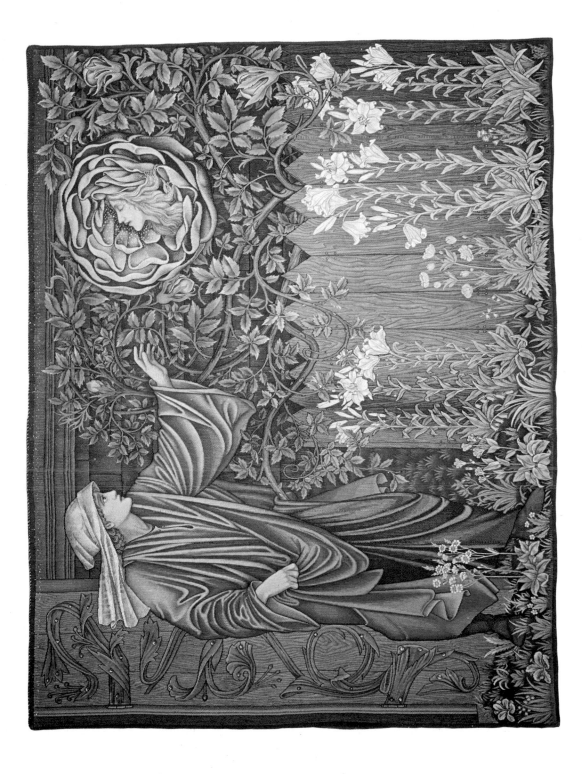

48

LOVE LEADING THE PILGRIM
1909 Wool tapestry 150 x 263.5 cm
Sotheby's Belgravia, London